**From Paintings and Notes
2015**

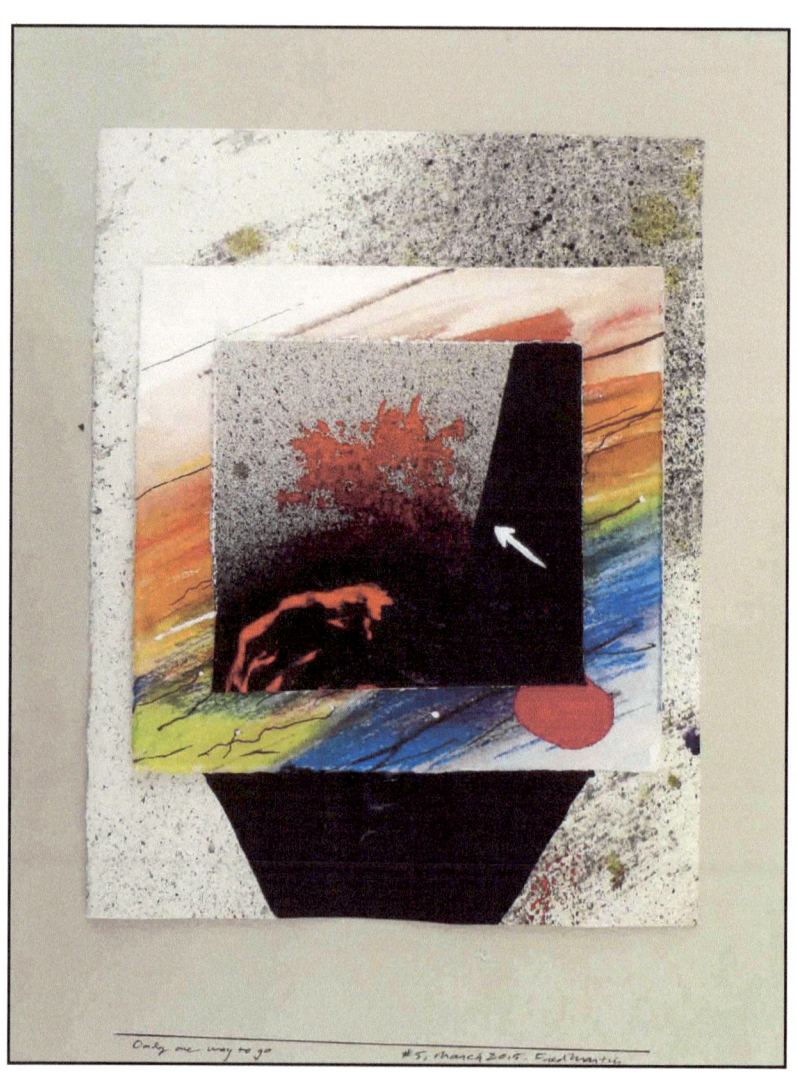

#5, March 2015.
11 x 8.5", acrylic with collage.
"Only one way to go"

From Paintings and Notes
2015

Fred Martin

What is there to do— better
What is there to know—deeper
What is there to say—find it
Where is there to go—be here now

Green Gates Press
2016

This book is dedicated to the reader.

© Fred Martin 2016.
Green Gates Press.
Isbn
978-1-365-09915-1

By way of an introduction, a work by another artist...

When Art Speaks
When art speaks a miracle occurs
Organs, an eye, an ear,
Sometimes an old heart is made new
No ordinary change
But a penetrating vision
Emerging from the artist's work
And all those who see it
Read the message, always timeless
Speaking what only the soul can see

The beauty that lies within
The inner need to reach, to touch
To say this is me, I need you
So we can be happy, powerful, and free
To live, to love, bear children
And grow in that knowledge
Leaving a memento of ourselves
For those who come after
Which simply says
It was good to be alive
To love as fully as we could

I leave you now a small note that says
This is what art means when it speaks

—Stephanie Zuperko

January 3, 2015. Montréal studio, late afternoon.

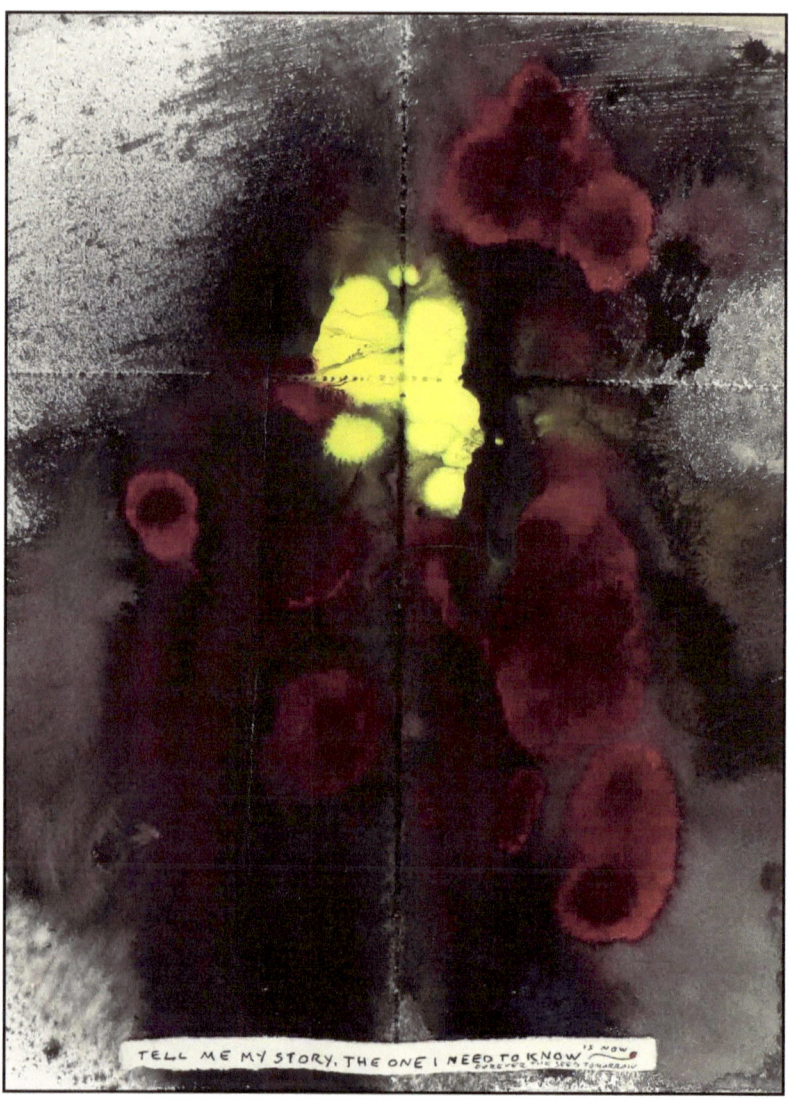

#1, January 2015.
Acrylic on paper with collage, 15 x 11".
"Tell me my story, the one I need to know
Forever the seed tomorrow is now"

January 3, 2015. Montréal studio, late afternoon.
Look at the studio—I don't live here. Make it so I do… Shift the lights, fill the wall with work.

Step 1.
Set up "pre-established harmony" on the format of the paper.
Take a 15 x 11" piece of paper scratch the surface with the diagonal, the counter diagonal, and the horizontal on the crossing point, and then fold.

Step 2.
Hear the message –
"Tell me my story, the one I need to know."
See the left over the end, see the come drop of the future—
"Forever the seed of tomorrow is now."

Put in the blots, wait for it to dry.

January 4, 2015. Montréal studio, afternoon.
And the message lower than where I had first seen it on the format…
"Tell me my story, the one I need to know—
Forever the seed [of] tomorrow is now"

Voilà! A poster to tell me what to do. It shows the blood and the light in the darkness.

January 4, 2015. Montréal studio, later afternoon.

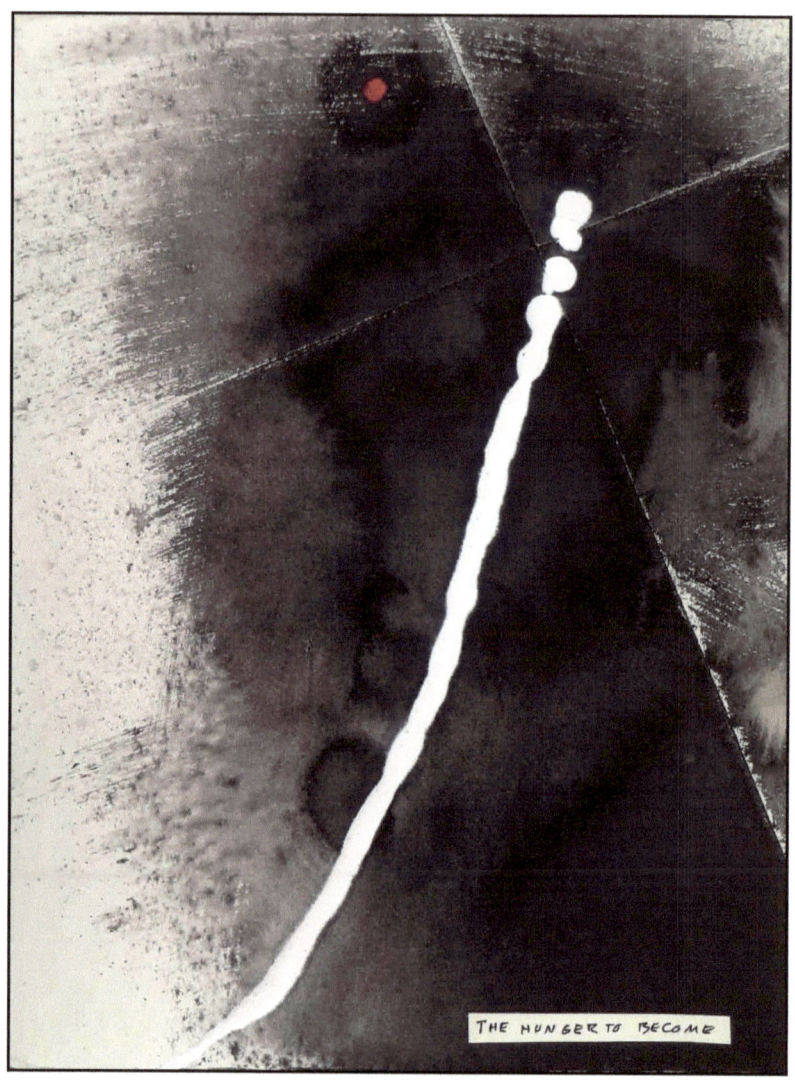

#2, January 2015.
Acrylic on paper with collage, 15 x 11"
"The hunger to become"

January 4, 2015. Montréal studio, later afternoon.
Hear the message for *#2, January 2015.*
"Sadness, sadness, all the days of past."
Do I want to say that? Well, I heard it.
So, shut up and wait to see what comes.

What came was
"All my life the dream to come tomorrow."
Became The Hunger
Became The Dream to Be
Became The Hunger to Become

January 7, 2014. Montréal studio, midafternoon.

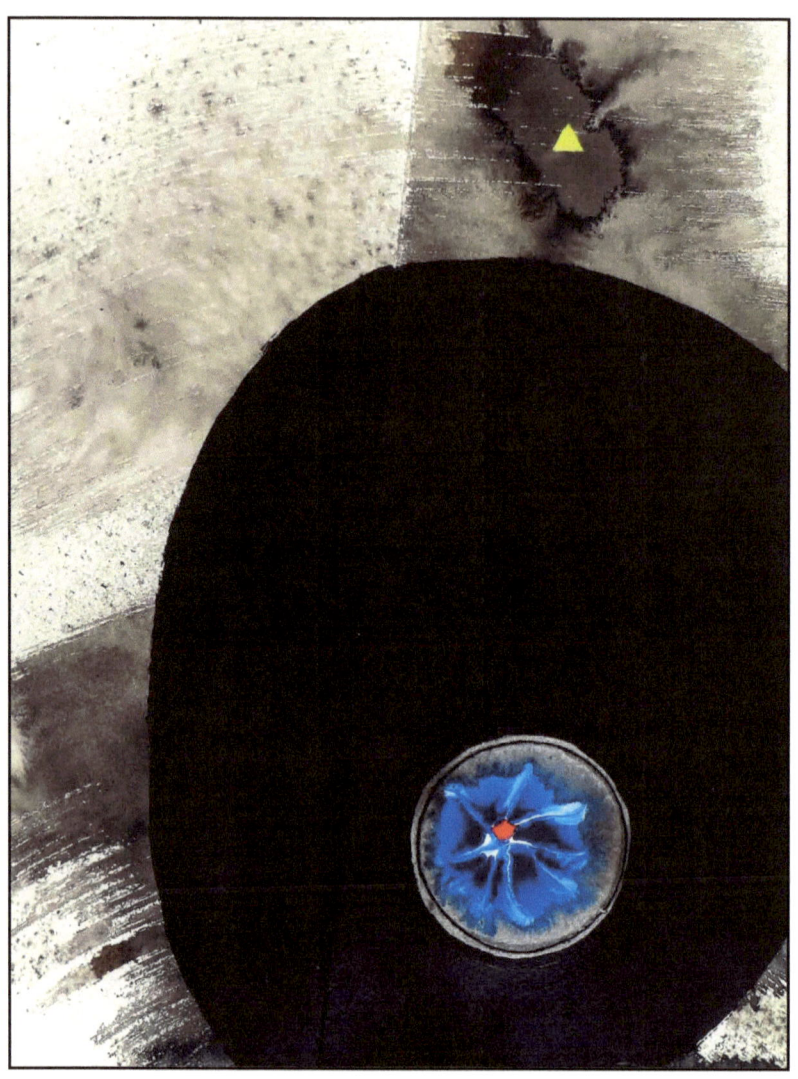

#3, January 2015.
Acrylic on paper, 15 x 11".

January 7, 2014. Montréal studio, midafternoon.
Making *#3, January 2015.*

The loss-ing, the gone-ing,
all the memories no longer there
in your failing mind.

Who and where and why are we?
Because he came in her.
Because.

Is becoming an "Origins" picture.
[Maybe put in the yellow triangle?]
[Or maybe only a dot?]

Night
Wait and see.

January 8, 2015. Montréal studio, late afternoon.
More about *#3, January 2015.*
The yellow triangle.
I heard yesterday—
"You see what you see,
I see what I see,
We none see what the artist saw"

Yes, he saw eternal re-birth because he [I] was afraid of death.

Late afternoon continued.
Look at all three January paintings –
#1, January. The light flaring in the root of my cock.
#2, January. The ejaculation.
#3, January. The eternal rebirth.

January 15, 2015. Montréal studio, night.
Looking at *#3, January 2015* while walking into the studio—"It's too perfect."

The next one, not.

January 16, 2015. Montréal studio, very early morning.

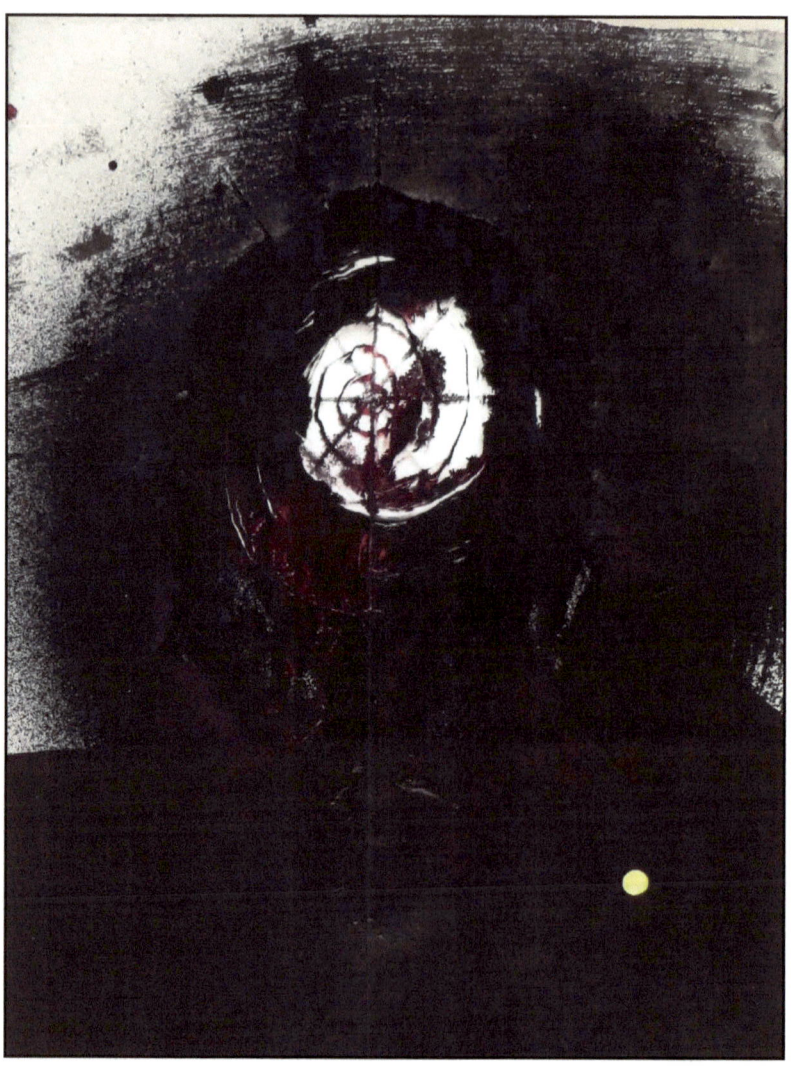

#4, January 2015.
Acrylic on paper, 15 x 11".

January 16, 2015. Montréal studio, very early morning.
Making *#4, January 2015.*

Put in the raw umber earth. Then see the seed.
Title: "It will come: New Life."

And, general looking, if I could make one of these per day, I could take the room.

Afternoon:
"It will come again."

January 18, Montréal studio, night.

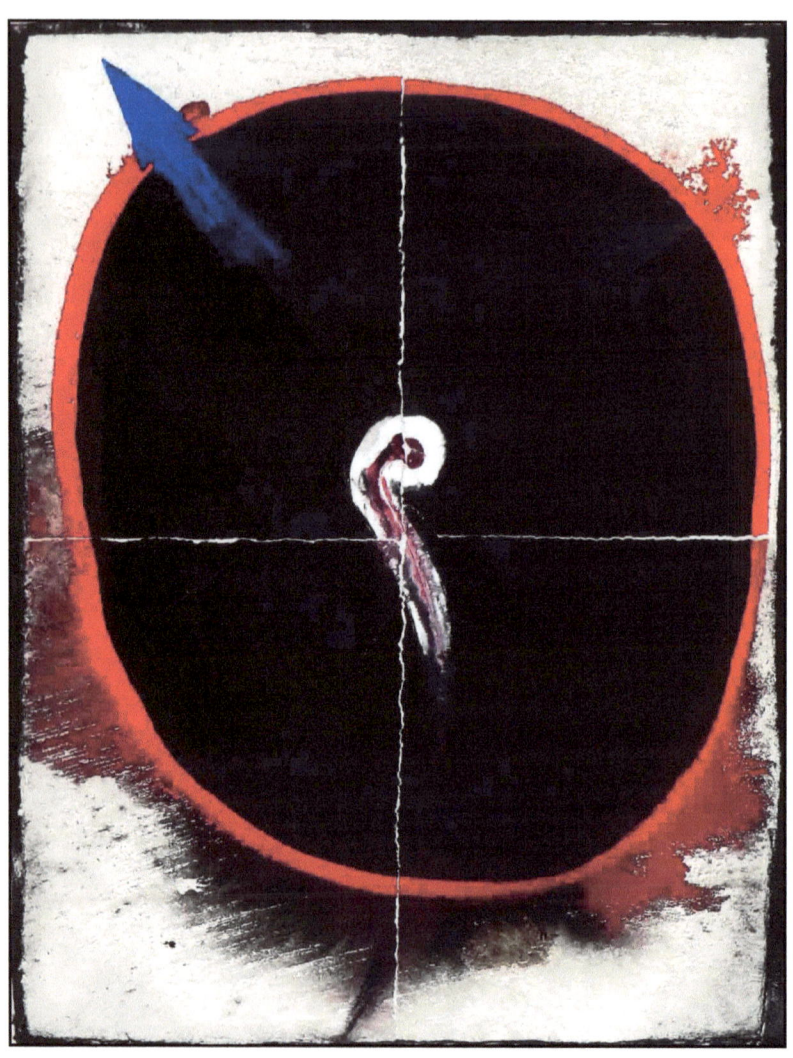

#5, January 2015. Untitled.
Acrylic with collage on paper, approximately 15.5 x 11.5".
Subject: Fertilization.

January 28, Montréal studio, late afternoon.
#5, January 2015.
Look at it—
The sperm cell, the ovum, the birth.

I looked at the five January 2015 paintings and I heard—
"What we make when we are afraid…"

What I make what I am afraid of old age and death, is the opposite:
Ejaculation and Birth.

January 29, 2015. Montréal studio, late afternoon.
About *#5, January 2015*.
"I shot an arrow in the air,
And if it landed,
I know not where."

January 31, 2015. Montréal studio, night.
Walking here, looking at *#5, January 2015*,
Yes, that's it. The conclusion.
Now, what's next?
Whence the arrow of my life?

February 4, 2015. Montréal studio, late afternoon.

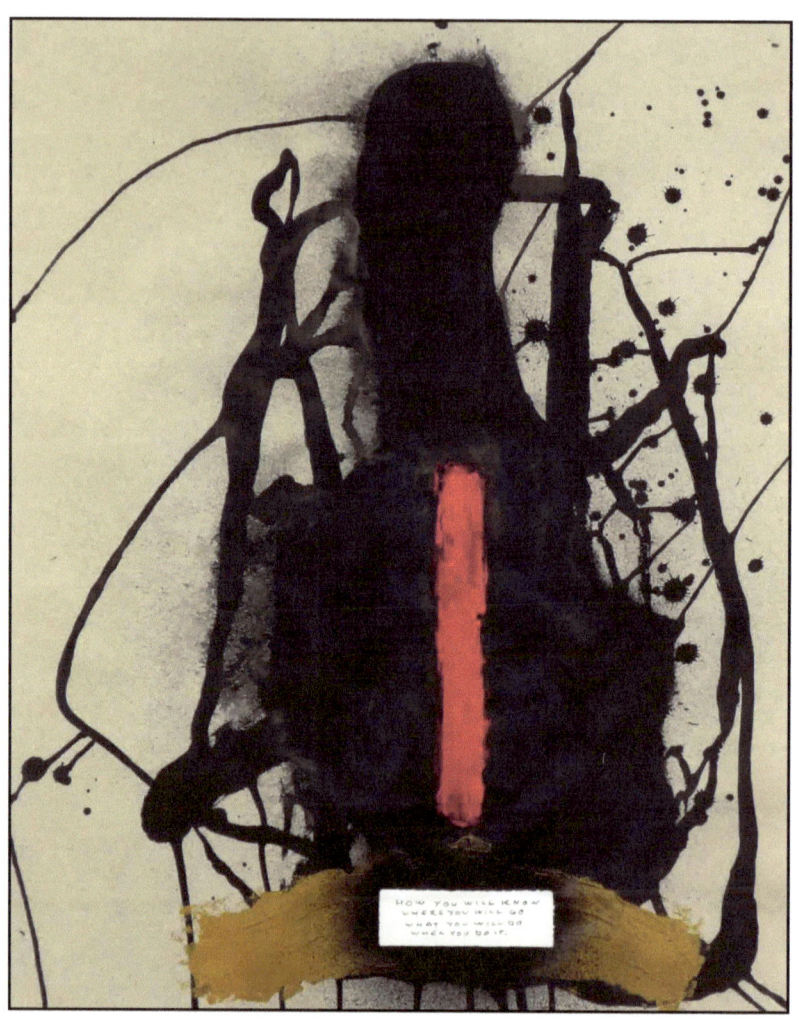

#1, February 2015.
Acrylic with collage on((Nepal?) paper, 24 x 18".
And the image shows the blood line.
Not the question but the answer.

February 2, 2015. Montréal studio, late afternoon.
Try Chinese ink and calligraphy brush on the gray 24 x 18" (Nepal?) paper.
See what happens

February 3, 2015. Montréal studio, late afternoon.
This morning I thought –
"How do you know
Where will you go
What will you do
When you do it?"

Look at the Chinese ink/brush on gray paper from yesterday. No.
So this afternoon I made with Chinese ink on white paper. No good.

February 4, 2015. Montréal studio, late afternoon.
So yesterday with Chinese ink didn't make it, today try fluid acrylic.
And, change the question to a statement.

How you will know
Where you will go
What you will do
When you do it.

#1, February 2015.
And the image shows the blood line.
Not a question but the answer.

February 5, 2015. Montréal studio, late afternoon.

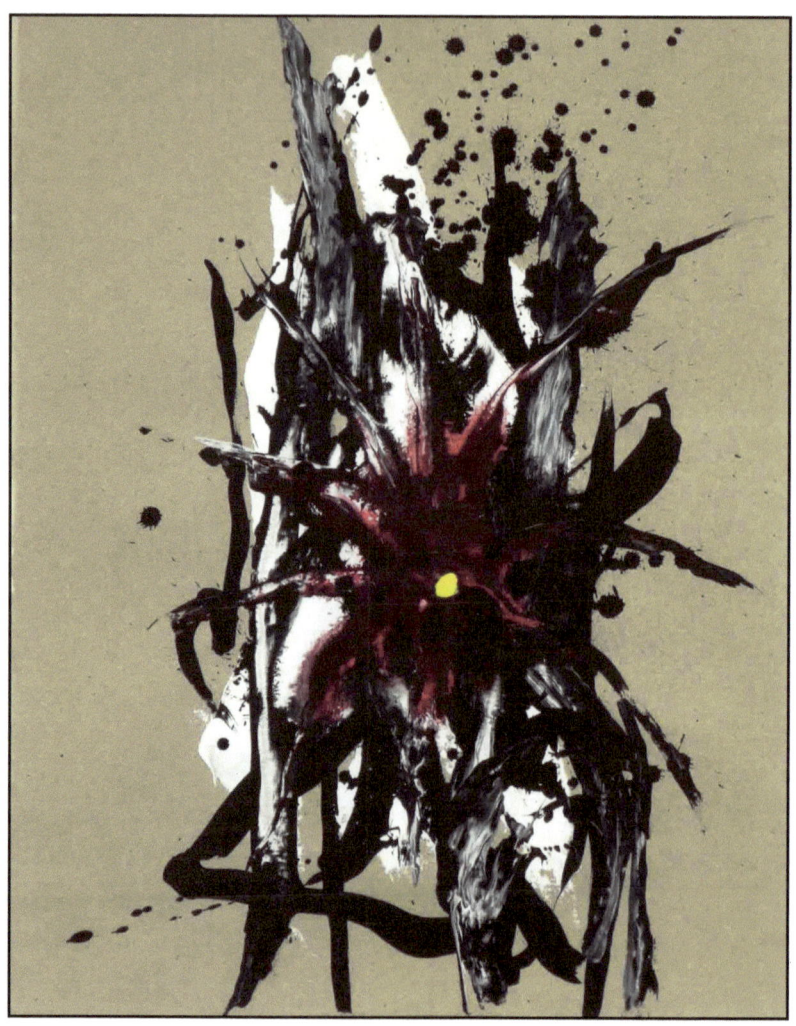

#2, February 2015.
Acrylic on paper, 24 x 18".
The white lines and the black lines, what is the knot?
It's the tomorrow of Forever.

February 5, 2015. Montréal studio, late afternoon.
#2, February 2015.
The white lines and the black lines, what is the knot?
It's the tomorrow of Forever.

February 6, 2015. Montréal studio, late afternoon.
Look at *#2, February 2015*.
Yes.

February 7, 2015, Montreal Studio, night.
The January paintings are such little things,
yet they are the signs of the lives of us all.

February 10, 2015. Montréal studio, night.

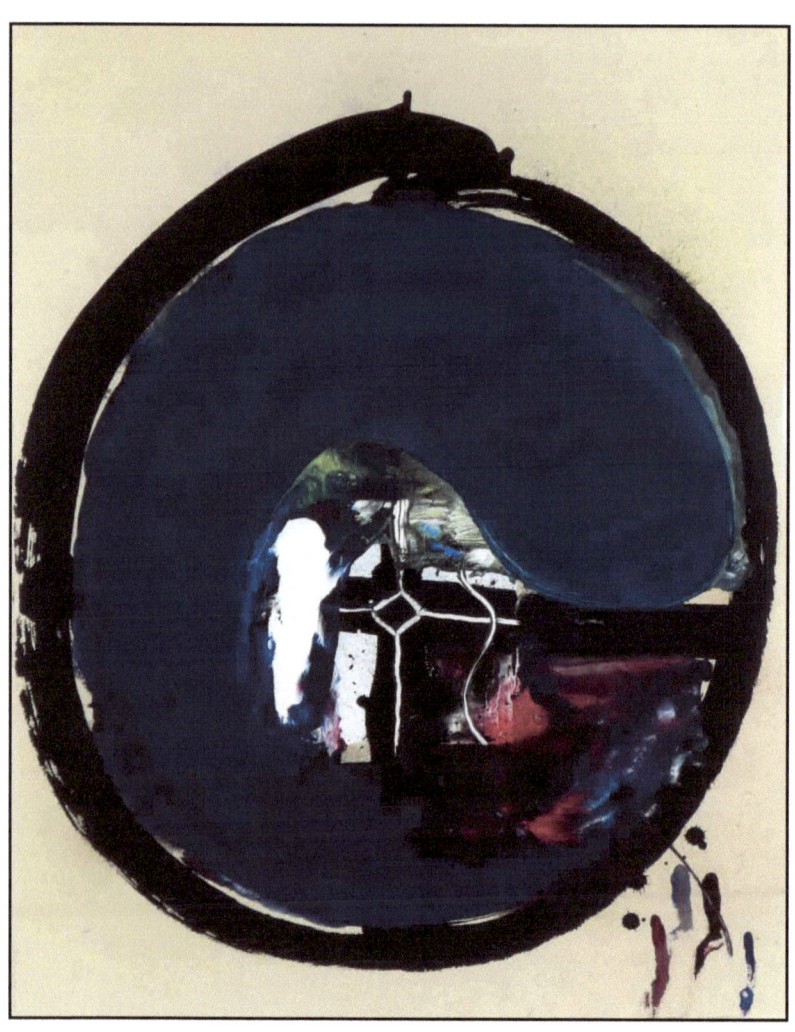

#3, February 2015

February 10, 2015. Montréal studio, night.
What I heard first, when beginning to clean up the studio, signing and packing the left over 2014's on the wall, putting away the January 2015's to make room for the two February 2015's…

"Keep on going down the road, the drain is just ahead."
I could see the drain in the gutter ahead, and sensed it was for me.

Then, working on *#3, February 2015*, it became hearing
"Keep on going downhill…"

And as the painting came could I see to make the drain not a pipe to the sewer but a path to a source?
Quit fake optimism.

There are streaky finger marks lower right corner. To cover them I heard, "Never give up."

February 11, 2015. Montréal studio, late afternoon.
Don't cover up the streaky finger marks.

February 11, Montréal studio, night.

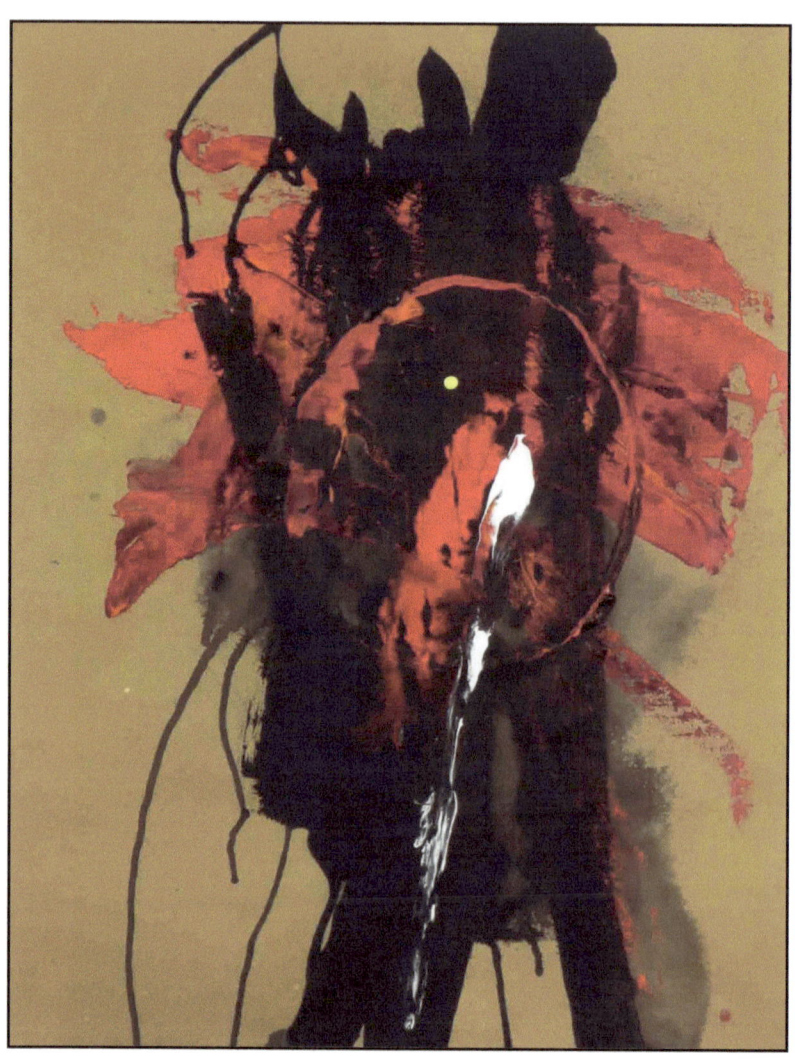

#4, February 2015.
Acrylic on paper, 24 x 18".
What I heard when near the end of making it
"Oh, let me be born."

February 11, Montréal studio, night.
Working on *#4, February 2015*.
What I heard when near the end of making it
"Oh, let me be born."

What I had been thinking about all afternoon was—
Near the ending,
Go up on the side of the mountain
Find the place to see far out over the land
Watch, hear the music of the world
And wait for the end.

What I got tonight is *#4, February 2015*.
And, looking at this and the other February paintings on this paper—

I see what I see
You see what you see
And not one of us sees
What any other one of us sees.

That's Western Individualism after the cultural core (religion) is gone.

February 12, 2015.
Put in the yellow dot.
That is the cultural core.

February 13, 2015. Montréal studio, night.

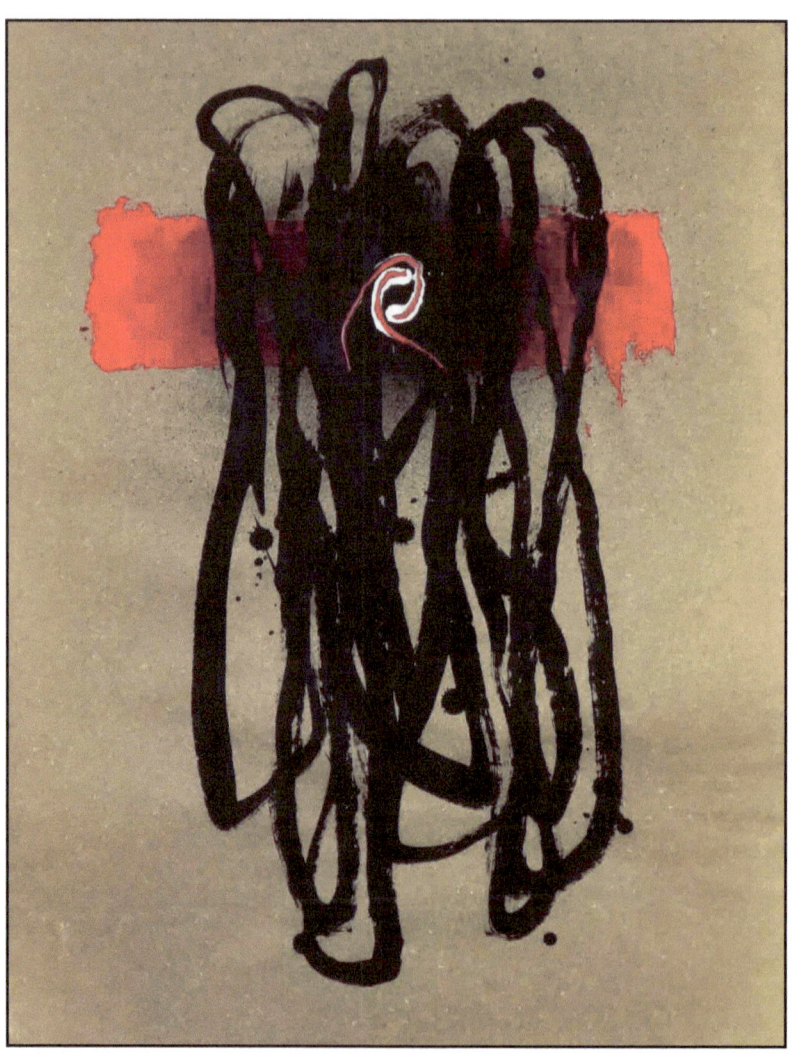

#5, February 2015.
Acrylic on paper, 24 x 18".

February 13, 2015. Montréal studio, night.
Working on *#5, February 2015*—
What I heard was
"Coming and going
And passing away"

What I made is this painting…

And that was all there was to it.

[The black calligraphies are infinity signs (∞) turned vertically—888's wound among each other and hanging from the blood smear.]

And I heard from me to say to people who ask questions—
"Sorry folks, simple's better."

Whoever thought that I would come out here?
Look at the 1968-70 acrylics, 1974-79 watercolors.

February 14, 2015. Montréal studio, early morning.
What I had heard in the beginning, was
"… Passing away."
But what I made in the ending is
"Forever more born."

February 15, 2015. Montréal studio, early morning.
I heard –
"Tell me the story
Tell me the story
Not the pretty that you want
But the truth I need to know…
Old age, decline and death.

March 5, 2015. Montréal studio, late afternoon.
Pick up all the scraps, make them permanent with old sayings.

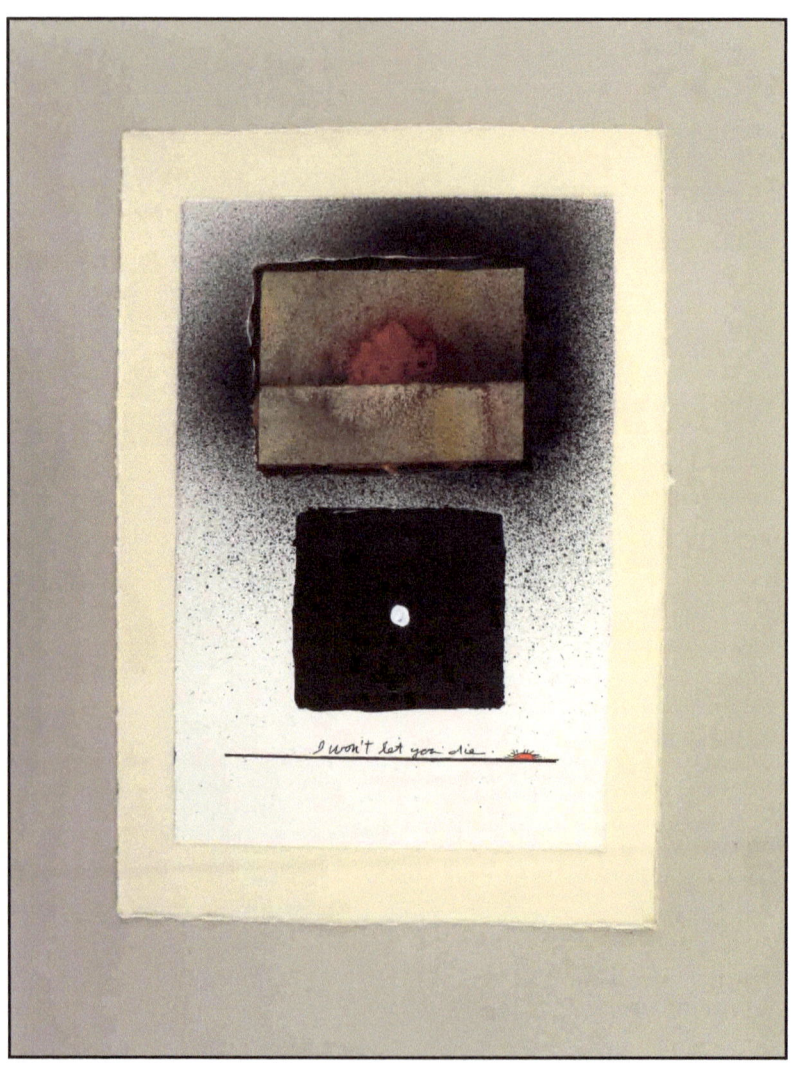

#1, March 2015.
Acrylic with collage 11 x 7.7".
"I won't let you die."

March 10-12, 2015. Montréal studio, late afternoons and nights.

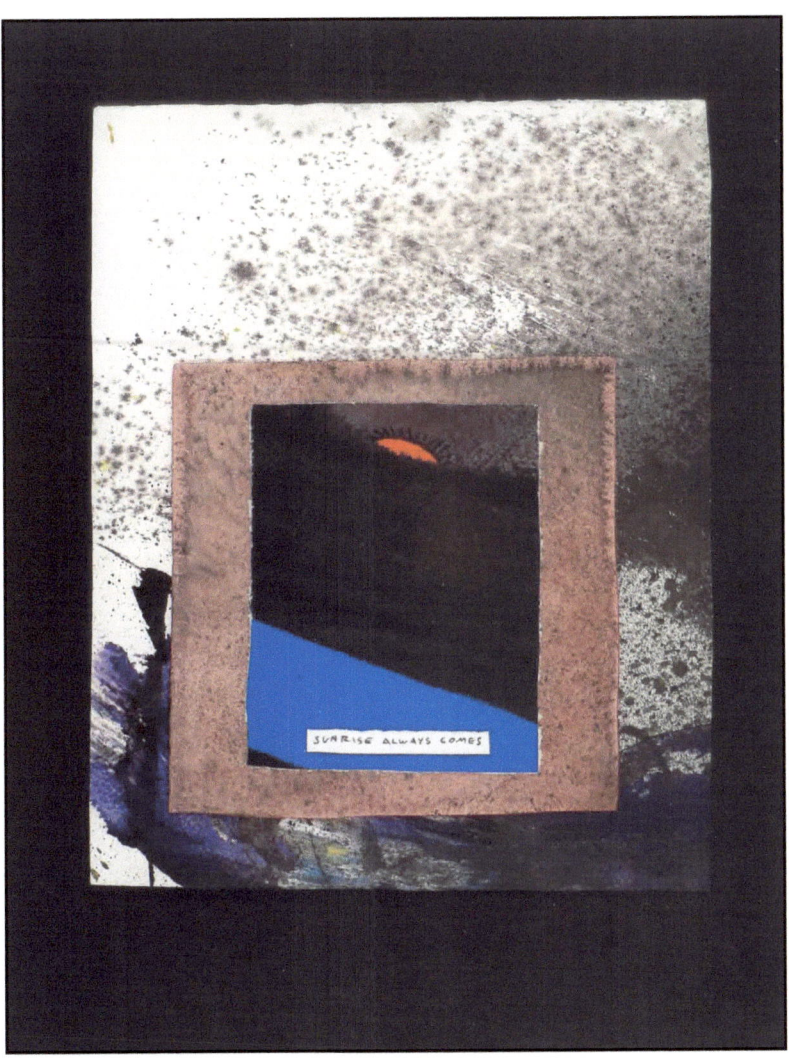

#2, March 2015.
Acrylic with collage, 11 x 8.5".
"Sunrise always comes."

March 10-12, 2015. Montréal studio, late afternoons and nights.

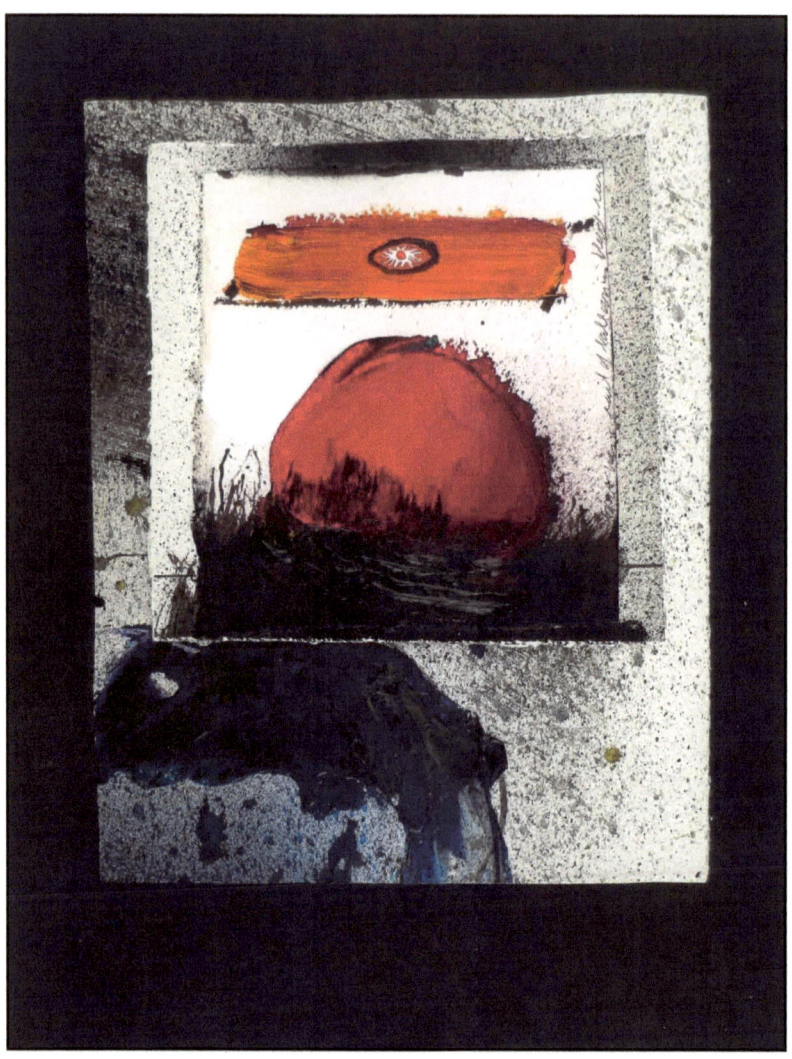

#3, March 2015.
Aacrylic with collage, 11 x 8.5".
"By my hand."

March 10-12, 2015. Montréal studio, late afternoons and nights.

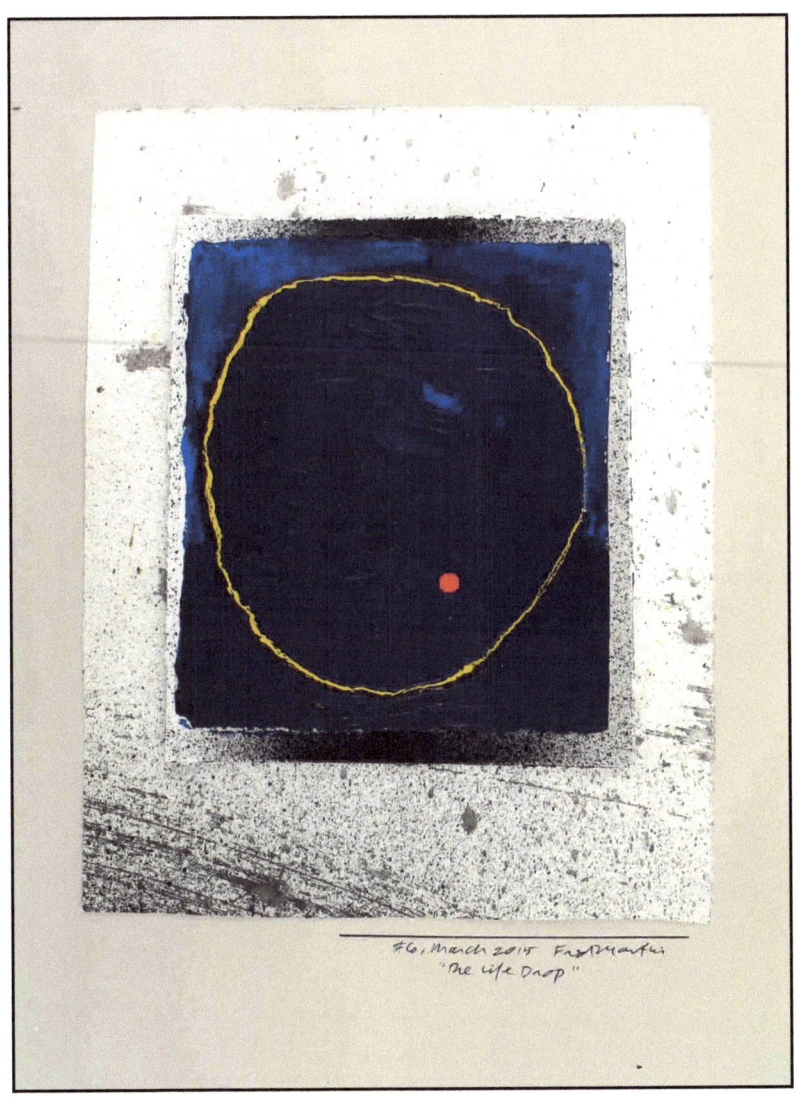

#6, March 2015.
Acrylic with collage. 11 x 8.5"
"The Life Drop"

March 10-12, 2015. Montréal studio, late afternoons and nights.

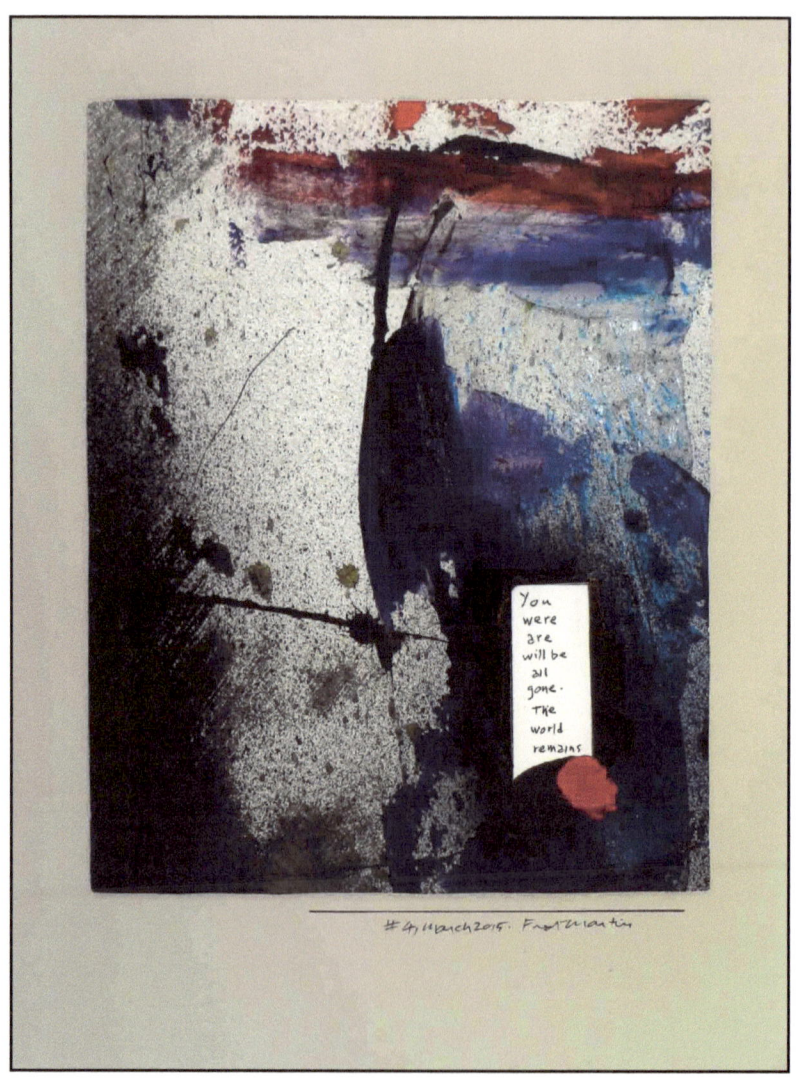

#4, March 2015.
Acrylic with collage, 11 x 8.5"
"You were are will be all gone.
The world remains."

March 10-12, 2015. Montréal studio, late afternoons and nights.

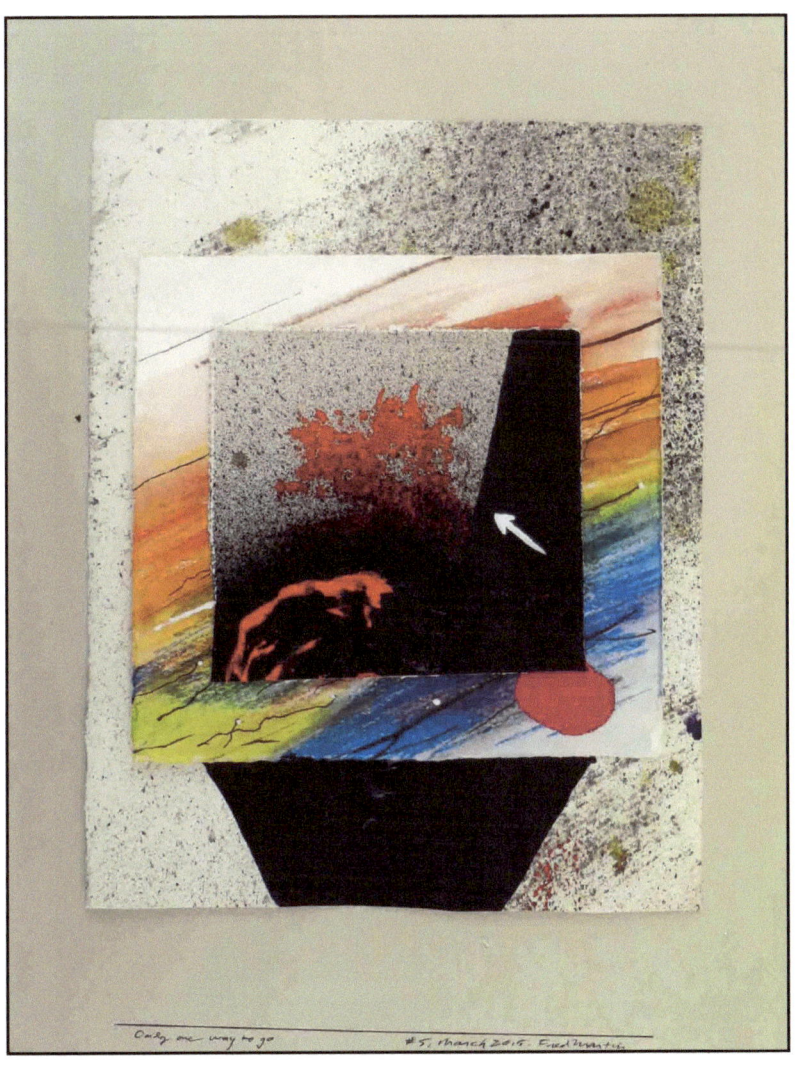

#5, March 2015.
Acrylic with collage, 11 x 8.5"
"Only one way to go"

May 6, 2015. Montréal studio, afternoon.

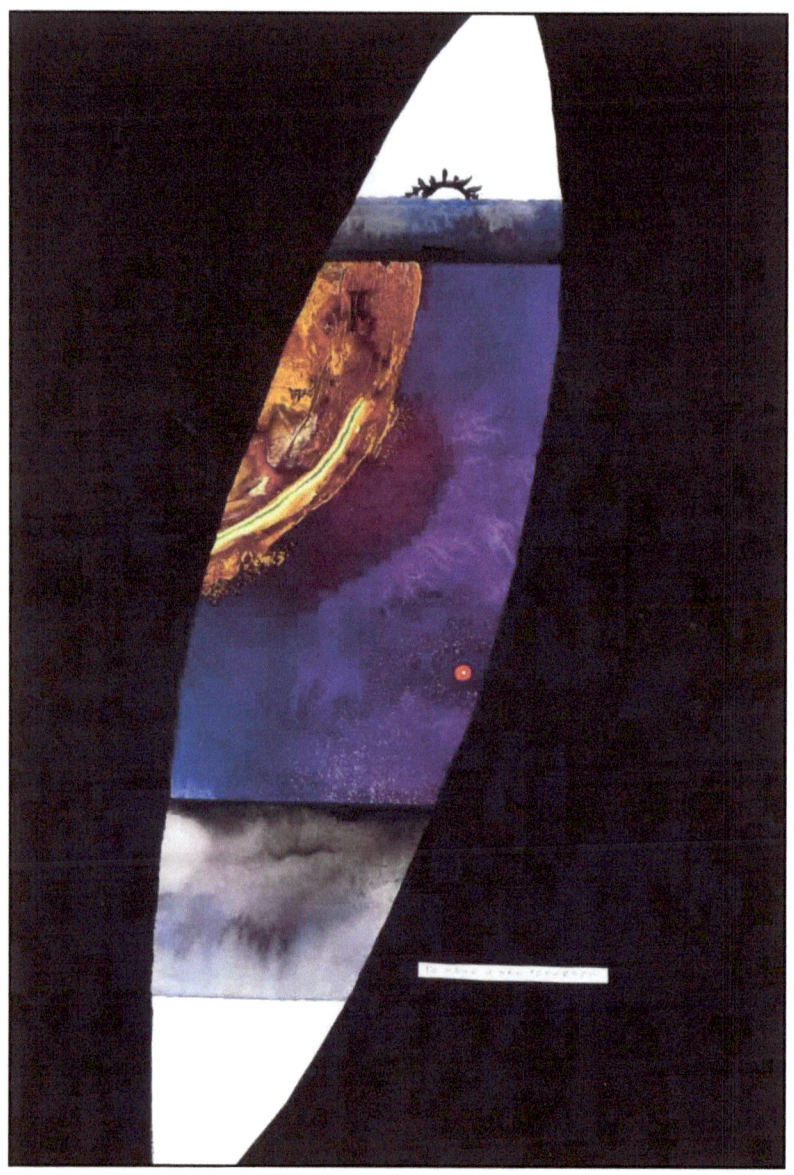

#1, May 2015.

May 6, 2015. Montréal studio, afternoon.
I've been thinking how to make it now for several days…
A manuscript to hold in the hand, see close, flooding the field of vision…

A painting, set on a wall, not touched, seen from at least 6 or more feet away—
more the wall and the site than the art object unless the painting is wall size (or a window into—"a picture of").

Well, anyway—
Night follows day and day follows night until one day your day doesn't.

Later thinking about and making
It is beginning to be to begin a new tomorrow.

A little later—
It's all come down to make a new tomorrow.

And there it is—
#1, May 2015.
Acrylic with collage on paper, 22 x 15 inches.
"To Make A New Tomorrow"

May 25, 2015. Montréal studio, 5:30 AM.
I heard, "It's time to get to work, Boy."

Anaximander's theory of the coming to be and the passing away will be made as a diptych—

The passing away and the coming to be… I've been thinking of this for weeks. The left side will be the passing away, and the right side will be the coming to be.

So, I told my Master,
"See, I did."

May 25, 2015. Montréal studio, 5:30 AM.

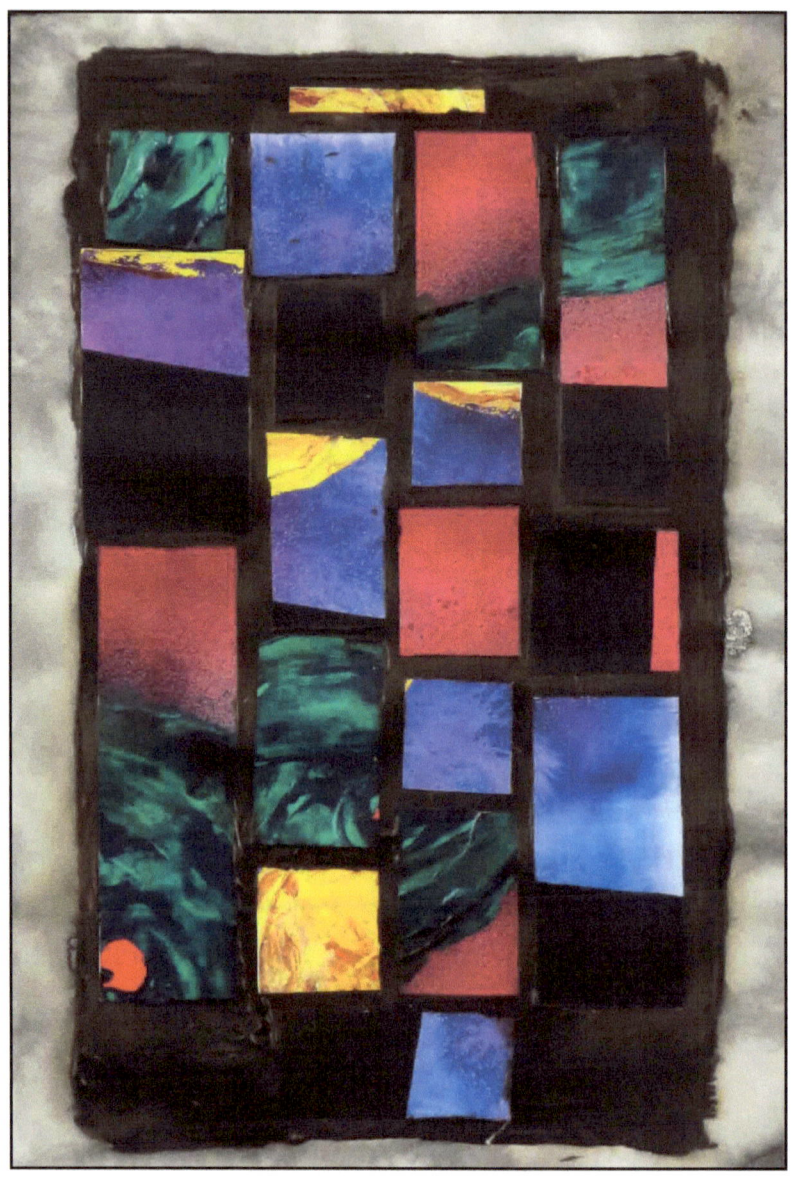

*#2a, May 2015.*Note: Re-named *#1a, June 2015*.
Acrylic with collage on paper, 22 x 15 inches.
"The Passing Away"

May 26, 2015. Montréal studio, 6:30 AM.

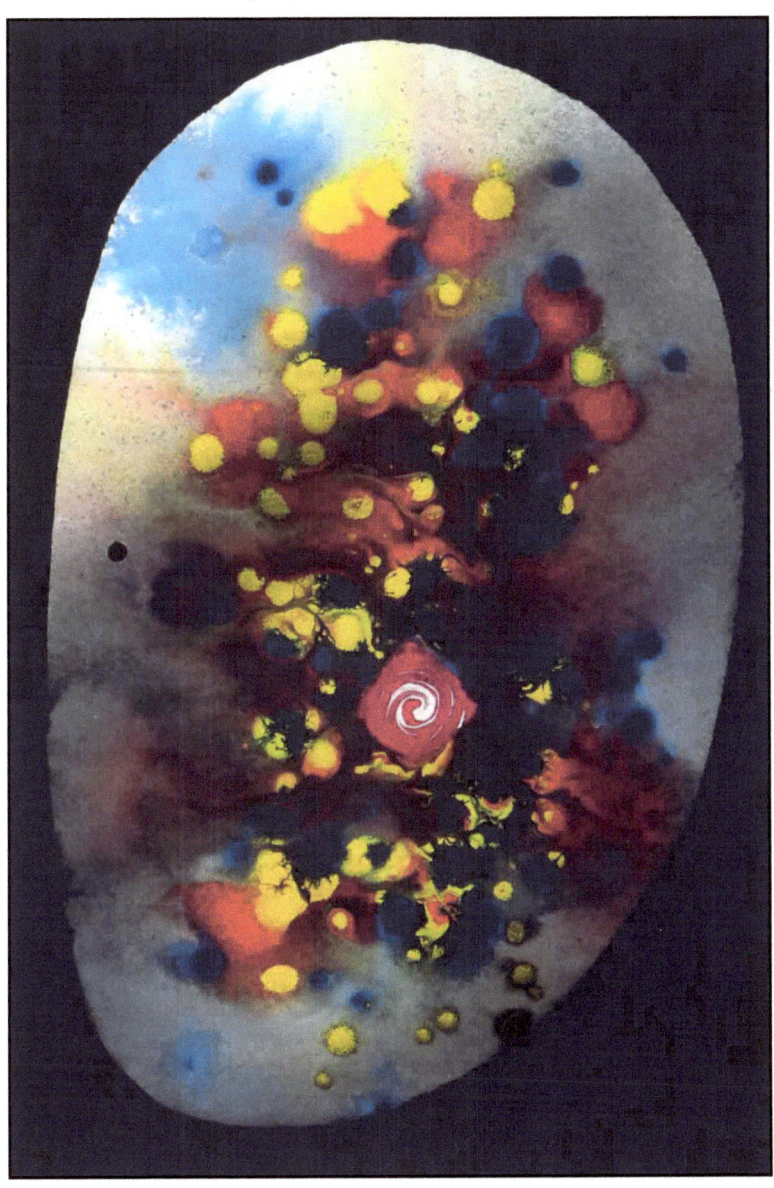

#2b, May 2015. Note: Re-named *#1b, June 2015*.
Acrylic with collage on paper, 22 x 15 inches.
"The Coming to be"

Early July, 2025. Montreal studio.

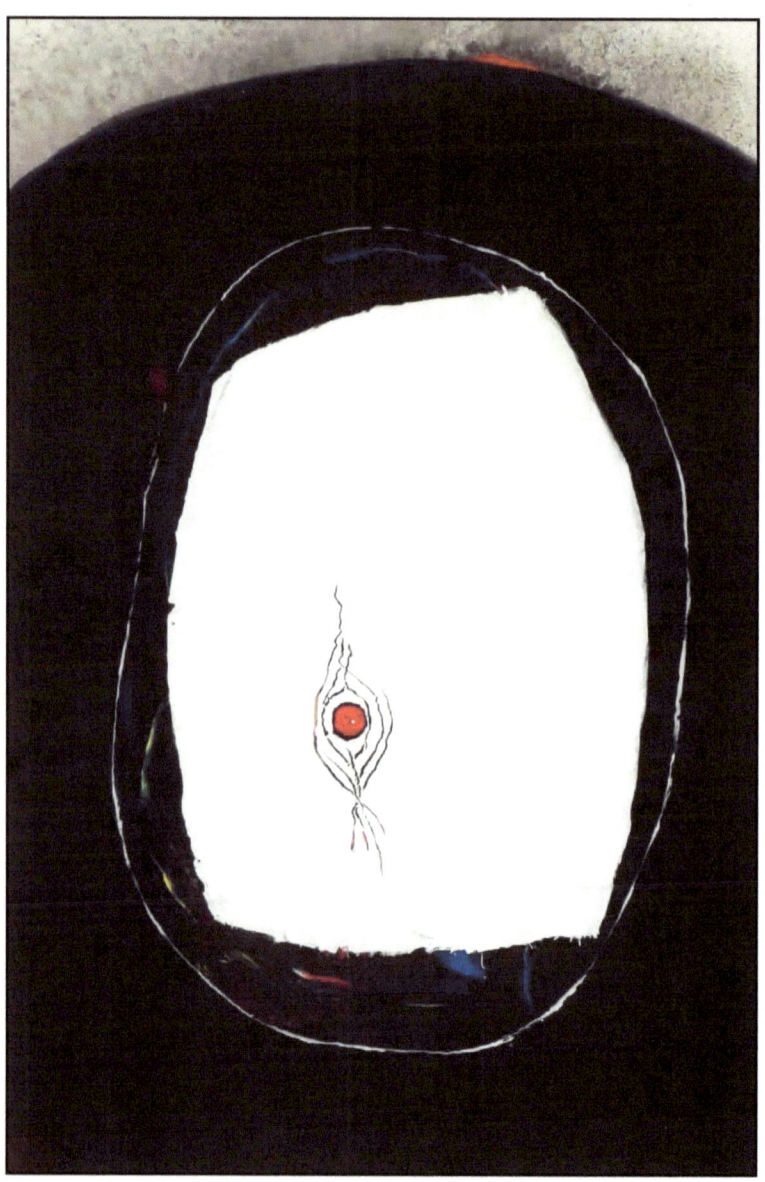

#1, July 2015.
Acrylic with collage on paper, 22 x 15 inches.

July 3, 2025. Montreal studio, 5 PM.

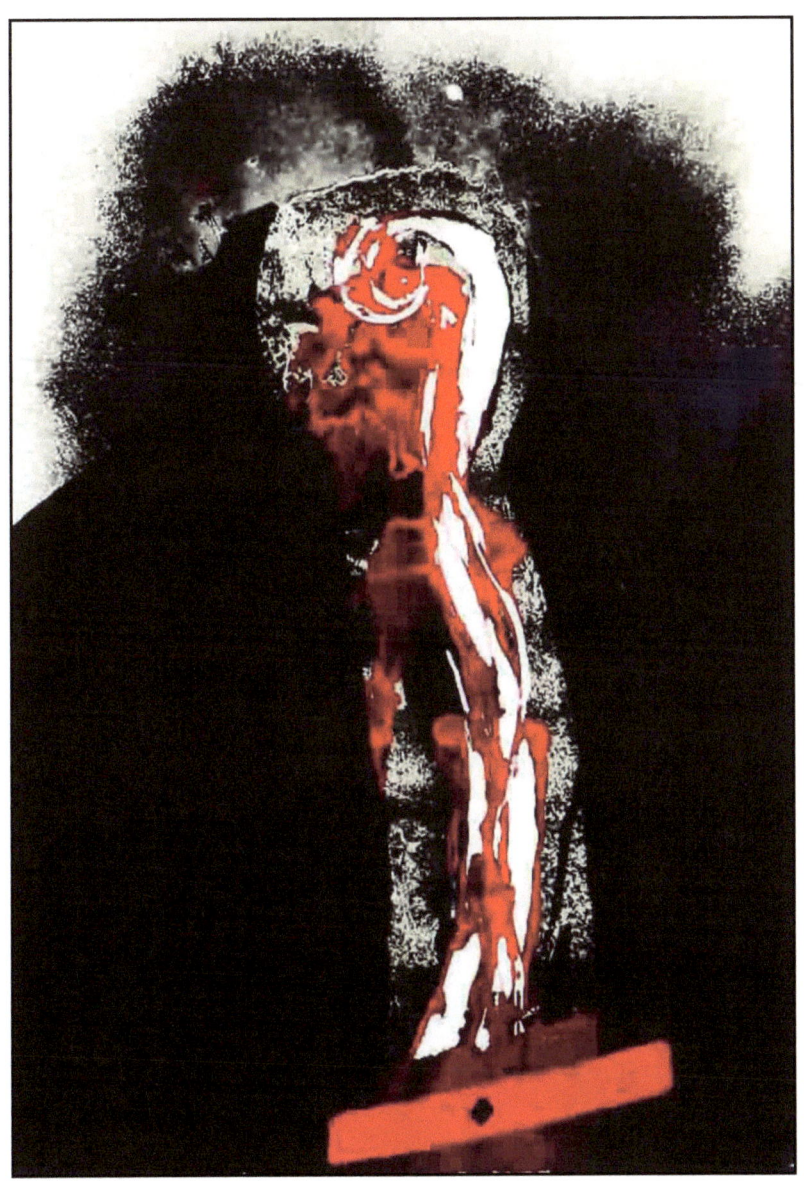

#2, July 2015.
Acrylic on paper, 22 x 15".

July 13, 2025. Montreal studio.

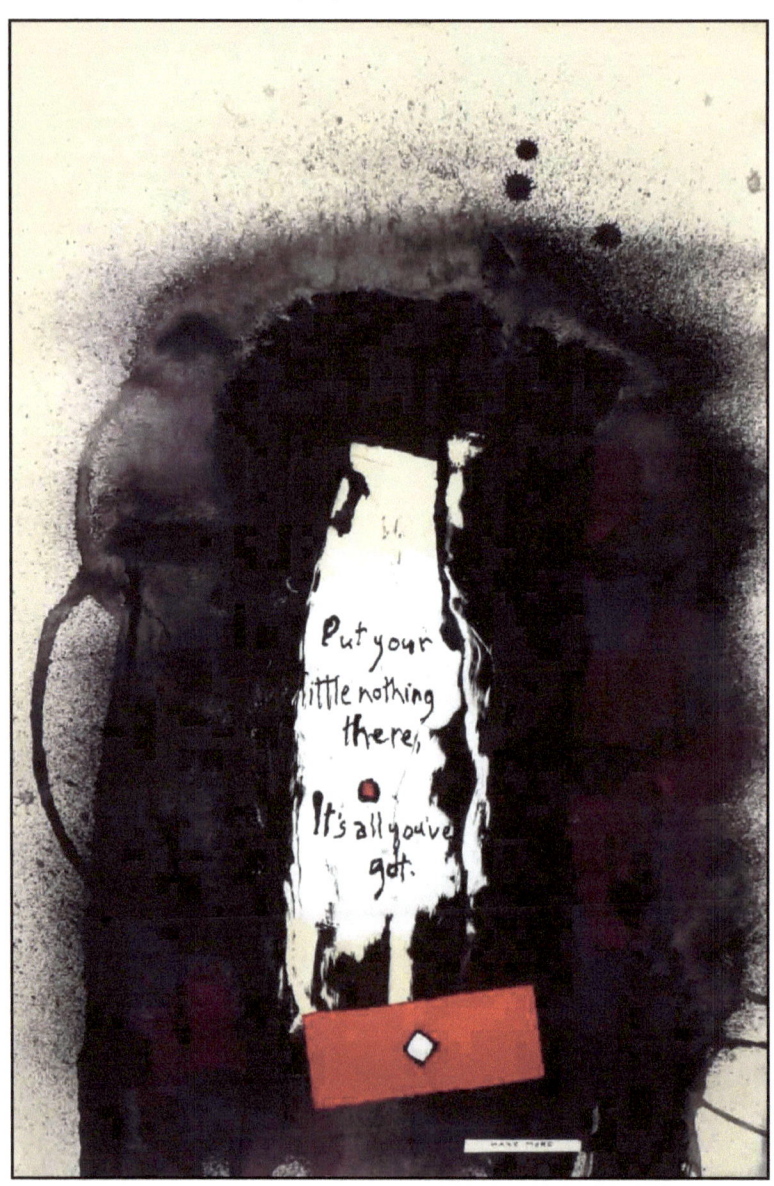

#3, July 2015
Acrylic on paper, 22 x 15".
"Make More"

July 19, 2015. Montréal house, early morning.
Everything is broken
Everything else was already lost.

Old age
Time is fleeting—
Each minute past
Is one less to come.

For the work to do
How much time remains?

July 24, 2015. Monte Vista studio, afternoon.
We make things. Without us and those things,
researchers and philosophers would have nothing to write about.

Researchers—the empirical investigators of perception and the hedonic response; philosophers—and each one's theory of knowledge and truth.

We make it, they write about it to tell us how to do it better for them. But what is better for us? The path of life… We each have a different thumbprint, and each have also a different journey.

August 13, 2015. Lac Ouareau, late night. (12:37 AM tomorrow)
"The gloomy gloaming…" Late life's life of daily life. (I had thought before so many better words but remember now only the first two seed words mangled from a disremembered song.)

What, oh what is it like as the candles fade out?
Some are broken, some are snuffed
Some only slowly, gently, the wax gone, die out.

August 18, 2015. Montreal studio, night.

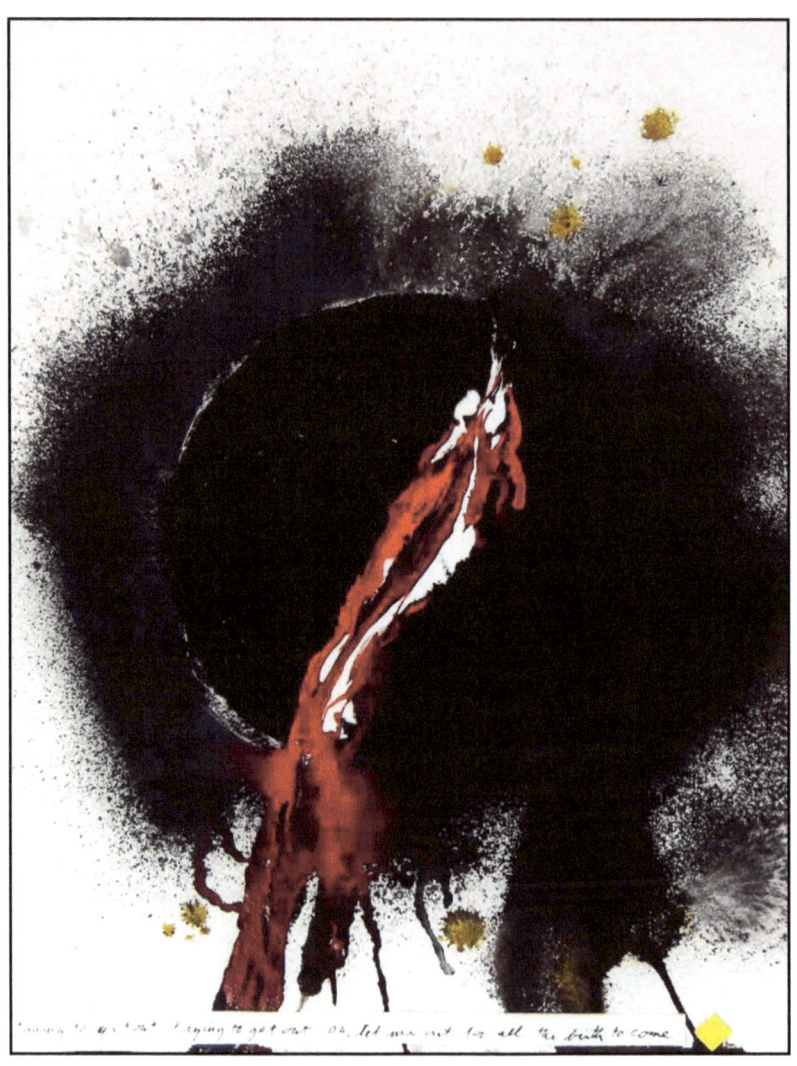

#1, August 2015.
Acrylic on paper, 18 x 13 3/8".
Trying to get out, trying to get out.
Oh, let me out for all the birth to come.

August 24, 2015. Montreal studio, early morning.

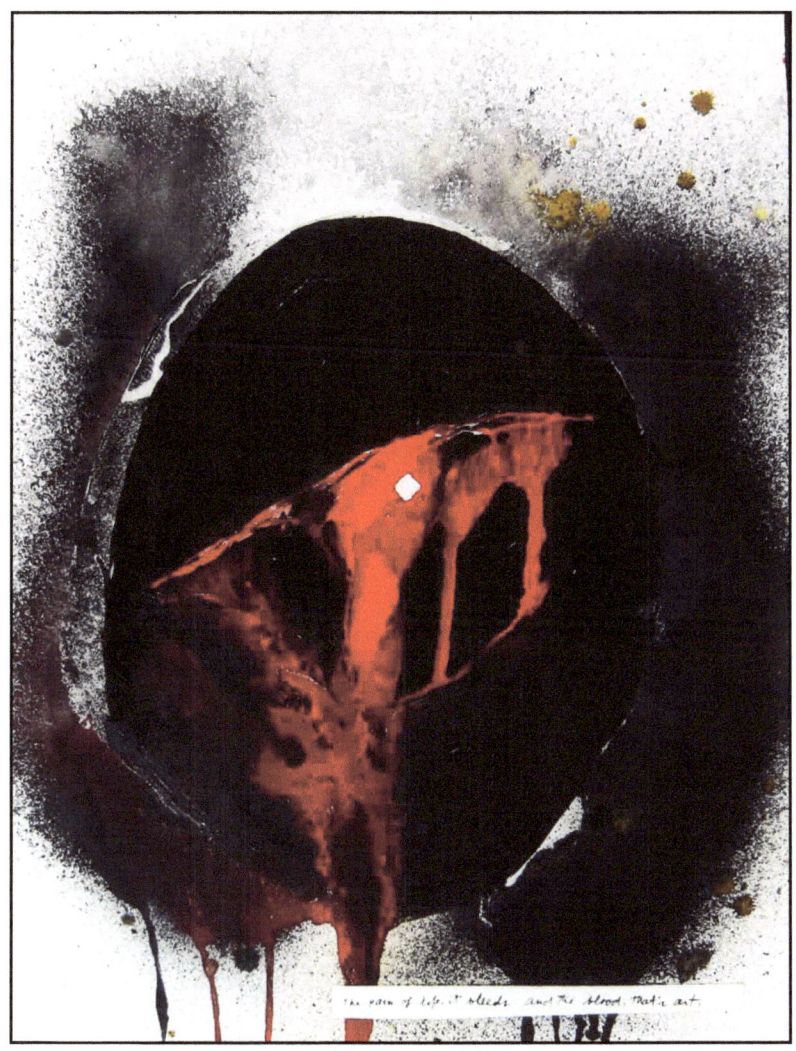

#2, August 2015.
Acrylic on paper, 18 x 13 3/8".
"The pain of life, it bleeds. And the blood, that's art."

August 27, 2015. Monte Vista studio, early evening.
The kind of studio here—the east room with the full moon rising.

What is there to make now?

 What is there to do— better
 What is there to know— deeper
 What is there to say— find it
 Where is there to go— be here now

September 26, 2015. Monte Vista studio, 2 AM.
Heard a helicopter fly over, very high. And then an ambulance siren, far off. Yes, late night, at least they have something to do with their lives. I don't.

October 14, 2015. 8:30 AM, Monte Vista studio.
And for art, if that's all I've got to say, it's all I've got to say. If you want more, go ask somebody else. Yes, just one or two scraps—the footnotes—of each day. Make the studio to be the place…

November 10, 2015. Monte Vista studio, 1 AM.
And for whom is my work made? Only for me to learn my story. For you, find your own. But is it that the image of the agony in me (not the story but the stretch) is for others the release of the agony in them? And is thus my work not only solipsism for me but also the release for the solipsism in everyone else???

November 15, 2015. Monte Vista studio, 12:30 AM.
For whom do you make it?
First, but then finally and always only yourself.

Forever after, everyone who sees, sees only themselves—their needs, desires, memories, regrets, hopes, fears and ends.
(Not that last, they don't want to look.)

December 15, 2015. Monte Vista studio, 5:15 AM.
Night gives the sunrise
Sunrise gives the dawn
Dawn gives the morning
And morning gives the noon.

Night gives the sunrise
Sunrise gives the dawn
Dawn gives the morning
and morning gives the noon

www.ingramcontent.com/pod-product-compliance
Lightning Source LLC
Chambersburg PA
CBHW041112180526
45172CB00001B/225